Schirmer's Visual L
Edward Hopper — Forty I

A mood of melancholy pervades the work of Edward Hopper (1882–1967). The leitmotif in his paintings is the loneliness of the individual in the cities and open spaces of America—the visual expression of a consciousness which has obvious parallels to the present day. In the last several years there has been a Hopper renaissance, particularly in Europe. Hopper's realism, based on his subjective impressions and observations, strongly influenced contemporary American art, and went on to become for many a compelling statement on American life, as can be seen in the countless photographs and films inspired by his motifs.

The forty paintings in this volume give a representative overview of Hopper's art. The introductory text was written by Heinz Liesbrock, an Americanist, Germanist, and art historian born in Duisburg, West Germany, in 1953. Liesbrock became interested in Hopper as a Fulbright Scholar at the National Museum of American Art in Washington, D.C.

120 pages, 40 color plates

Edward Hopper

Forty Masterworks

With an introductory essay by Heinz Liesbrock

W.W. Norton
New York London

Cover Painting:
Nighthawks, 1942
oil on canvas, 76.2 × 152.4 cm
The Art Institute of Chicago

The publisher wishes to thank Doris Palca and Anita Duquette
of the Whitney Museum of American Art, New York, for their kind assistance in
the preparation of this volume.

Translation from German by Anne Heritage and Paul Kremmel

Reproductions: O.R.T. Kirchner & Graser GmbH, Berlin
Composition: The Sarabande Press, New York
Printed and bound in Germany

ISBN 0–393–30764–6

A Schirmer/Mosel Production
Published by W. W. Norton & Company
New York · London

Contents

Heinz Liesbrock
The Silent Truth of Light: Edward Hopper's Oeuvre

I

Edward Hopper had already assumed a central role in American art by the 1930s. Yet in spite of his status as a classic artist, "one of the giants of American painting," as he was once called, a vivid force still emanates from his work today. Within the pulsating trends and fashions of the art world since the 1940s his work not only has maintained its individuality but also has continued to show new facets and even greater richness. Thus, for many "abstract expressionists," Hopper, who was the first to establish the international reputation of American art in the 1950s, was a model and example. The strict formality of his paintings pointed the way for their study of color and simple forms. [1]

In Europe, Hopper's paintings were discovered later but became known all the more rapidly and extensively. The retrospective of his works shown in three European cities in 1981 not only established his reputation among art critics but also made several of his paintings widely popular. Hopper's paintings have frequently appeared as cover illustrations for literary works, and *Nighthawks* in particular is often encountered in public places. The reasons for this popularity are not immediately obvious, but some of Hopper's paintings clearly reflect the consciousness of our time. A nostalgic element is a part of this—similarities between Hopper's scenes and those in *film noir* have repeatedly been pointed out—as well as a specific view of modern life. Hopper's paintings are seen as icons of an all-encompassing social malaise. Almost as a caricature of this interpreta-

tion, a collection of articles on alienation theories published in Italy a few years ago decorated its cover with *Nighthawks.*

Initially, an interpretation of his works as depicting man's situation in the modern world seems justifiable. Hopper was a witness to the hectic twenties and the Great Depression of the thirties; in his paintings the loss of faith in technology and in ever-increasing prosperity is documented. For him, architectural forms and technology are able to express isolation and loss of orientation as much as the human figure. But his pictures also show that Hopper was interested in more than the depiction of a particular historical situation and that his view of reality goes beyond the human sphere. In the span of his work we repeatedly encounter paintings in which human beings are excluded, scenes in which vegetation or the sea is depicted with only a few other objects — in particular, evocative architectural forms. Careful scrutiny reveals that these pictures follow special laws of painting that are based not on normal, everyday perception but on a form of seeing that is aware of the structures in color, lines, and surfaces. Objects like trees, bushes, streets, and houses no longer appear to be determined purely by human understanding, which perceives them as utilitarian objects; rather, the emphasis on their formal qualities gives them a special, purified, even liberated, appearance. In Hopper's world both objects and nature are stamped with an aura of clarity, quiet, and rapture. His paintings thwart hasty judgments as well as interpretations limited to the human sphere. They stand by themselves and do not seem to require the human perspective. What fascinated Hopper was the quiet image of objects in light, the play of movement and rest, of material substances and their disintegration in shadow, all of which are brought about by light. Hopper's interest, like that of all other true artists, was determined primarily by the eye and its characteristic forms of experience.

Human beings often seem to disturb his perception, introducing an element of disquiet and creating moods that are initially intense but nevertheless transitory. Hopper himself said: "I guess I am not very human. I didn't just want to paint people posturing and grimacing; what I wanted to do was only to paint sunlight on the side of a house."[2] Thus, it is not surprising that the people in his paintings are almost always caught up in themselves, unable to perceive the world outside, i.e., to do what distinguished Hopper as an artist: to see, to open one's eyes to the world and discover truth in visual appearance.

2

Outwardly Hopper's life was extremely stable, free of any turmoil. Once he had found himself as an artist, his life was dominated by his career and rarely touched by the society around him. Nevertheless, from his distanced vantage point, Hopper remained an acute observer of his times and its art movements, a wealth of experience that is reflected in his works. It is therefore useful to look first at the forces that shaped his life, in order to help illuminate the special characteristics of his art.

Hopper was born in 1882 in Nyack, a small port on the Hudson River several miles north of New York City. Indeed, the East Coast left such a strong impression on him that he can be regarded as a prototype of this culture. His strong inner-directedness can be traced to the Protestant, Puritan background of his family, which was the predominant influence during his childhood and youth. This introversion nurtured the persistence and decisiveness that also lent his artistic activity the necessary strength and perseverance. His art was strongly influenced by visual

impressions from his childhood: the street scenes of American small towns appeared again and again, scenes that had virtually vanished by the fifties and sixties. Here especially we note the quiet ambience of Victorian architecture, with the varied interplay of sunlight; there are no drive-ins, fast-food restaurants, or superhighways. He was equally influenced by the luminous atmosphere of the coastal region, and the ships and boats of his pictures were a part of his childhood experience on the Hudson.

In a very particular way, Hopper is an American painter, for it is his native scenery that characterizes his mature works and makes them unique. This, in spite of the fact that Hopper began his artistic training when it was not considered acceptable to derive pictorial motifs from American life or the American countryside. When he began his studies in 1900 at the New York School of Art, American art was still dominated by the worn-out European tradition of genre, landscape, and historical painting. It was Hopper's teacher Robert Henri who called for a national art, thus giving a decisive impetus to the development of American painting. Henri insisted that the artist base his work on the visual forms and specific problems of his time; only in this way could American art free itself from the tutelage of European tradition. Even though Henri's influence on Hopper's execution and style of art was short-lived, his insistence on the national quality of art had a lasting effect on Hopper's work.

Henri's idea of art was by no means nationalistic; what he meant by "national" was the given cultural heritage that every artist must come to terms with in order to reach personal and artistic maturity. The knowledge and acceptance of other cultures is just as much a part of this maturing process. On Henri's advice, Hopper went to Europe for several extended stays from 1906 to 1910. In retrospect, Europe meant France, and more specifically, Paris, for him. This city, its architecture, light, and

art tradition, decisively affected his development. It speaks for Hopper's inner strength and personal vision that even as a young artist he remained aloof from current influences and movements, allowing himself to follow his own personal ideas and intuition. When he arrived in 1906, Paris was the artistic center of the Western world; no other city was as important for the development of modern art. The move toward abstract painting was already underway; Cubism had begun. There, in 1907, Picasso painted his legendary *Les Demoiselles d'Avignon.* Hopper, however, later maintained that when he was in Paris he never heard of Picasso or of Gertrude Stein, who was to become so important for the development of modern literature.[3] For Hopper, the encounter with Impressionism was decisive. The light in these paintings and the thematic treatment of architecture and nature particularly attracted him and were to influence all of his work. His reaction to the Impressionists is directly reflected in his own art. He forgot the dark, Old Master-like interiors of his New York student days; his palette lit up and he began to paint with light and quick strokes. Paris and its atmosphere attracted him; he painted its bridges, buildings and parks, and the Seine, but especially its light. Completely within the Impressionistic tradition, he tried to capture on canvas the fleeting moments he had observed.[4] And although these paintings cannot hide a groping, sometimes awkward, element, they still exhibit the intimacy and atmospheric strength that are so characteristic of his later works.

In 1910 Hopper returned to the United States, never to leave North America again. His European experiences, however, retained their importance for him, his world view and cultural identity having changed decisively during his travels. Even in 1962 he could say, "I think I'm still an Impressionist."[5] How much France affected him can be seen in the problems he had in readjusting to American life. In the following years he

continued to exhibit the pictures created in Paris and to paint his impressions of France: "It seemed awfully crude and raw here when I got back. It took me ten years to get over Europe."[6] *Soir Bleu* (Plate 1), painted in 1914, exemplifies this confrontation with his European experience; Hopper was still inspired by French art, such as the works of Watteau, and his enraptured view of France is quite obvious in this painting.[7] Only very gradually, initially in geographically neutral landscapes, did he begin to show an interest in the American world. In this phase, architecture, which was so typical of his later works, barely played a role. Not until the twenties did he begin to forget his impressions of France, and later they no longer appeared in his paintings at all.

Why Hopper found it so difficult to deal with American themes again can be seen in his work itself. Hopper was never a mere reporter of external reality or of social misery, and the national pathos found in the art of the American Regionalists, which was popular in the thirties, remained foreign to him. His growing familiarity with the world around him was part of a process of finding himself, an essential precondition for a particular artistic quality. Hopper expressed the personal nature of this process when he said, "The American quality is *in* a painter—he doesn't have to strive for it."[8] This statement also shows that Hopper, in his depictions of America, was concerned with the complex mediation between his personal, inner reality and the external world. His eye wanted to remain true to the visual appearance of the outer world, but he equally sought to convey a comprehensive quality, an empirically undefinable force that he alone perceived. He sought to give visual expression to the complex relationship between people and their environment. Another statement expresses this desire: "Great art is the outward expression of an inner life in the artist, and this inner life will result in his personal vision of the

world. . . . My aim in painting is always, using nature as the medium, to try to project upon canvas my most intimate reaction to the subject as it appears when I like it most; when the facts are given unity by my interest and prejudices."[9] To reach this goal every artist needs to maintain a certain distance to the world around him. If he is unequivocally a part of it, he will not be able to recognize it. In France, and after his return to the United States, Hopper had to learn to accept this distance and strangeness. As was the case with many American artists, especially writers, he was able to truly *see* his own country only after having experienced Europe. Mark Twain, Henry James, F. Scott Fitzgerald, Ernest Hemingway, and William Faulkner all shared this experience.

In 1924, with an exhibition of watercolors depicting the landscape and architecture on the Atlantic Coast in Maine, the artistically mature Hopper achieved the recognition that led to financial independence. At this juncture his works displayed the characteristic style he was to perfect and intensify during the rest of his life. In the more than forty years that Hopper was still to live, he would return again and again to those few motifs which enabled him to mediate between the outer world and his inner vision. His life centered completely on his art, the society around him playing no significant role. In 1924 Hopper married the artist Josephine Nivison, and their marriage was to remain the most important human relationship for both of them. They led steady and secluded lives, spending almost every summer on Cape Cod, where many seaside and coastal paintings were created. This rhythm was only occasionally interrupted by trips to the Western states and Mexico. Hopper died in 1967, in the studio on Washington Square that he had moved into in 1913.

3

The steady rhythm of Hopper's life is reflected in the structure of his paintings, which are all variations on a few basic themes. A summary of these motifs leads directly to the center of his work: houses in the sunlight on a coastline or in the country, surrounded by trees and bushes with a unique intensity and atmosphere. And his cities: often pure architectural masses towering above the human figures. Finally, man himself in rooms and in front of houses, quiet and introverted, which is why no real encounter takes place between his figures. What is important is how Hopper saw his objects, preferring to portray them early in the morning or at night, removed from human presence. Thus, in *Drugstore* (Plate 6), or *Seven A.M.* (Plate 32) the objects in the shop windows take on an unusual, compelling aura in the neon light or early-morning sun. And his portrayal of architecture, emphasizing the formal, disregards the human element. The houses in pictures like *Early Sunday Morning* (Plate 15) or *House by the Railroad* (Plate 4) display such individuality that they can be seen as independent entities.

A first look at Hopper's work reveals the important role that light plays in evoking the atmosphere characteristic of his paintings. Natural and artificial light create a borderland of either clarity or oppressive density. Some of Hopper's paintings from the twenties show how his depiction of light defines the human situation. In *New York Restaurant* (Plate 3), *Eleven A.M.* (Plate 5), *Two on the Aisle* (Plate 7), *Automat* (Plate 8), and *Chop Suey* (Plate 11), human subjects are portrayed in social situations like an evening at the theater or a restaurant, although none of these pictures tells an

actual story. Where the people come from, where they are going, what they are looking at, is peripheral. What primarily interests Hopper is creating a specific atmosphere, transcending the momentary, in which man is viewed comprehensively. Hopper referred to this intention in a comment on *New York Restaurant:* "In a specific and concrete sense the idea was to attempt to make visual the crowded glamour of a New York restaurant during the noon hour. I am hoping that ideas less easy to define have, perhaps, crept in also."[10] It is obvious that his special use of light is important for expressing what is "less easy to define," namely, the way in which light isolates the human figure in a room, and how light and shadow formations become an independent element, thereby giving the interior new shape and meaning. The viewer's eye is led to these zones of light, which are independent of the human figures and objects. The dynamics of the human encounter are lost in this kind of light. The figures are engulfed in a strangely dense atmosphere that impedes their movements and forces them to look into themselves, away from the person facing them, away from the outside world in general. *New York Restaurant,* for example, is a tranquil painting in which time stands still and the everyday scene has been transformed. *Chop Suey,* the last painting from the nineteen-twenties, clearly shows the direction Hopper's art was to take. This painting is a formal construction of lines and flat surfaces in which color and especially light-fields take on an optical reality of their own, independent of the concrete objects depicted. The predominance of formal values corresponds to the speechlessness and motionlessness of the figures. Furthermore, it becomes clear that this play of light imbues the objects with special importance in contrast to the human subjects. The pot and bowl on the table, each a visual unit together with its shadows, are meant to be not objects used by man but primarily a combination of form

and color, thereby assuming an independent existence. This autonomy is also evident in the neon sign outside and the coat hanging to the left. Since both of these objects are traversed by a field of light, their status as independent objects is particularly striking. What we observe here is a living exchange between objects and light, taking place without man's awareness. The objects can, of course, be recognized and classified according to their everyday function, but at the same time they are portrayed as formal, abstract entities and thus take on an independence apart from their usefulness. For an understanding of Hopper's work, it is essential to recognize the autonomy the objects have assumed.

Roofs of Washington Square, a watercolor painted in 1926 (Figure 1), illustrates this process. The roof, chimneys, and windows are not objects for human shelter but are simply forms built according to the laws of spacial harmony and coloring. The painting, however, does not exclude man, but rather assigns him the role of observer. The rows of chimneys face the viewer and, by including him, urge him to perceive their purely physical presence. Only such an "absolute" way of perceiving, which transcends appearances and does not categorize objects according to their usefulness, can reveal their true significance. In this watercolor Hopper developed his "art of seeing," which was to become central to his entire work. The photographer Joel Meyerowitz explained what Hopper meant: "I learned that there was power to be found in the most ordinary things if you knew how to look at them. The way to look at them, Hopper was showing me, was hard: 'Look to the point of fascination,' he seemed to say, 'don't turn away. Trust that if you stand long enough to lose yourself you'll see something. And if you learned how to wait, things . . . would slowly seep into your mind and acquire a gravity, a significance that could be measured with paint and feeling.'"[11]

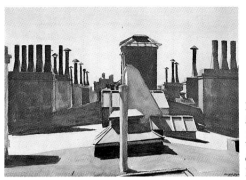

Fig. 1
Roofs of Washington Square,
1926
Watercolor, 35.6 × 50.8 cm
Collection Mr. and Mrs. James H.
Beal, Pittsburgh, Pa.

In *Roofs of Washington Square* it is the sunlight that captures the viewer's eye and invests the objects with their visual power. The transparent, evocative lighting underscores the concrete reality of the chimneys; it transforms the roof into a bright stage on which the red-colored forms and their dark shadows are cast.

<div align="center">4</div>

Hopper's scenic paintings also display the importance of light as a dramatic element. The mood in pictures such as *The Lighthouse at Two Lights* (Plate 12), *Lighthouse Hill* (Plate 9), *Cobb's Barns and Distant Houses* (Plate 17), *Captain Kelly's House* (Figure 2), and *Solitude* (Plate 28) depends on the special character of light at different times of day, the light also creating a common basis for architectural forms and natural phenomena. Architecture's geometric order and nature's more varied structure are brought together by the clearly delineated shadows, which, however, retain their transparency; the two spheres thus attain balance and harmony. It is obvious, however, that this balance can be achieved only by freeing the buildings from their human context. Lighthouses, farms, or living quar-

ters are depicted not according to their function but rather according to their outward appearance in a natural context; the vertical thrust of the lighthouses is just as much related to the dynamics of the landscape as are the spatially differentiated elements and colors of the farmhouses. At the same time, however, we continue to associate these buildings with human activity. This consideration helps us to see that nature in *Cobb's Barns and Distant Houses, Captain Kelly's House,* and *Solitude* has an unfathomable quality, an elemental energy that overpowers the human sphere. The rigid forms of man-made structures are called into question or even threatened by nature and its amorphous growth. Initially we are affected by the powerful mood of these paintings, an intensity that arises regardless of whether or not the human figure is portrayed. The power these paintings have is achieved not only by the special use of color but also by the thematic treatment of the horizon and the light that emanates from it. In *Solitude* the road leads directly to the horizon; the observer's eye is thus led automatically toward it. The two other paintings achieve this emphasis by allowing the viewer to see the horizon only in the very upper edge of the picture.

What do these paintings tell us about the human sphere? We have already pointed out that only the outward forms of the buildings are presented to us. The fact that the inside of the buildings cannot be seen supports this impression. Windows are perceived only as form and color; they do not allow us to look inside into the human sphere. Furthermore, in *Solitude* there is no pathway to the house through the high grass. No one appears to have entered or to have left, and the asphalt road is no longer in use. Vegetation is the theme of this painting: the experience of its movement in the wind, its intense growth, which questions the distinction between the plant world and the human sphere. The grass has grown so

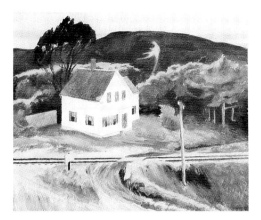

Fig. 2
Captain Kelly's House,
1931
Watercolor, 50.8 × 62.8 cm
Whitney Museum of American
Art, New York
Bequest of Josephine N. Hopper

densely around the house that it seems to have taken over. The painting, therefore, suggests a future in which the house with its ordered structure of surfaces and angles will be dissolved by the amorphous power of vegetation.

In the watercolor *Captain Kelly's House* (Figure 2) this theme is even more clearly expressed. The contradiction between civilization and nature is portrayed as a conflict between man-made forms on the one hand, and the plant world and light on the other. A warm, intensely colored, nearly formless vegetation is contrasted with a rectangular building painted in garish colors. The contrast is so sharp that the form of the house can no longer be seen as a pictorial element alone, harmoniously integrated into the painting as a whole. Instead, the house appears to be a symbol of human life. Although a clearing in the vegetation has been made for the building, and the meadow cut to prevent the house from being grown over, it is obvious that this rectangular, gleaming white building could be not only engulfed but actually destroyed by the warm light and lush vegetation. Not even the wall protecting the back of the house can coun-

teract this impression: the growth of the vegetation is not to be stopped. It has begun to move in on the wall, and the grass from the woods menacingly approaches the clearing. Finally, we notice that the grass is encroaching upon the pathway in the foreground, that the white milepost and the white sign at the railroad crossing have taken on a strange, heavy appearance, as if they had merged with the ground. Man's position in nature is endangered, for he has not been able to integrate nature into the structure of his own reality.

Even if this extreme conflict between nature and civilization is not found in all of Hopper's art, it does help to explain how he portrayed human subjects in his paintings.[12] More important than this clearly defined contrast, however, is the suggestive mood of Hopper's landscape paintings. They all try to capture a subjective feeling that has no visual form of its own. Hopper's basic theme is the mediation between the internal and the external. This is seen in *Solitude,* where we are unable to look inside the house, and where the horizon as motif points both to the visual forms of the world and to elements that transcend the world: we can perceive the evening light reflected in the objects but not the light itself or its source. Hopper's paintings do not depict a specific setting in the real world; rather they create, using the methods for portraying the empirical world, an all-encompassing quality that addresses man's most intimate side, a subjective perception of the world that structures his entire experience. Thus, in *Solitude* we sense the presence of the ocean, of human beings, and of their cities. Even though these elements are not visible, the force that emanates from the painting testifies to their reality.

5

In the light of our preceding observations on the relation between nature and the human sphere, it is not surprising that even those paintings which clearly portray people are dictated by the silence of an inner reality, regardless of whether the pictorial background is that of a small town in Pennsylvania or of New York City; the people always seem to be subject to an unseen force that restricts their movements and negates any real action. At times the paintings hint at some form of interaction, but apparently only with the intention of negating it. The sidewalks are empty and deserted, there is no traffic on the streets; both function merely as formal elements, together with the architecture. In *Western Motel* (Plate 38) there is no sign of the restlessness so characteristic of American life; instead the automobile and the street have become part of the still life-like interior. *New York Office* (Plate 39) shows no trace of the hectic pace of city life but rather appears as a place permeated with light in which the people are as motionless as the architecture. The woman's activity is inhibited by the space surrounding her, which is so completely devoid of reference points that we presume her arm has been frozen in this position for some time. Her body seems to have become rigid at the moment her eyes focused on the light from the street. Hopper was interested not in the hectic routine of the city but in this transitory moment, which he has preserved and extended beyond the strictures of empirical time.

Likewise, in *Conference at Night* (Plate 30) we are presented not with a familiar office scene but with empty tables and a faint, unconvincing attempt at interaction. The statue-like figures with their mask-like faces

exchange empty glances. The people are locked up in themselves, and any attempt to break out gets lost in the empty space around them. Thus, here too a configuration of objects and figures has been constructed to enable the play of light to develop and unfold.

Three of the best-known Hopper paintings provide a definitive statement on man's inner constraints, on his alienation from the external world. *Gas* (Plate 26), whose specific mood makes it perhaps the most moving painting of all Hopper's works, defines the human situation once again in connection with a natural setting. The picture goes against our conventional associations of a gas station. Not traffic and bustling activity but a quiet, secluded setting is shown. It is hard to imagine that a car at this gas station could make its way back to the road, especially since the pole and the high grass make the access appear too narrow. The important feature of *Gas* is that the contrast between the human and the natural spheres is defined both by the formal contradiction between architecture and vegetation and by the light. The man is placed in an area of harsh, almost white light, whereas nature around him displays a warm, manifold colorfulness. Behind a gas pump we see the figure of the man, fragile and leaning forward, apparently seeking protection from the glaring neon light. His presence pales in contrast to the high, upright pumps, which threaten to crush him. They are patterned on his contours, repeating his shape, thus making him part of the row they form, unable to stand out on his own.

In many of Hopper's paintings the subjects' feelings seem to be paralyzed; their eyes turned in upon themselves, they are not able to recognize the beauty and variety of the outside world even when they are directly confronted with it. In *Gas* the man's look is captivated by the gas station itself while nature's quiet illumination unfolds behind his back. *Cape Cod*

Evening (Plate 21) is dominated by the pervading mood that we have already observed in his other depictions of nature. Here this mood is manifested above all in the structure of the trees. Their oppressive colorfulness captivates us with a succession of deep blue tones that finally merge into a nearly black region where our eye settles. The visual structure of the forest has little in common with a realistic depiction; we perceive it as a reality of color and unstructured form. It is this reality, which mediates between the concrete material structure and its dissolution, that characterizes the hidden theme of this picture and all of Hopper's works. In the visible objects we sense a delicate quality that we know is not necessarily inherent in the objects. This is also evident in the impressions conveyed by the objects, such as the movement of the grass and the fine blue haze with which the forest projects its unique quality onto the couple's house.

The couple portrayed in *Cape Cod Evening* illustrates the dilemma of many of Hopper's subjects and helps us understand why his landscapes often hint at a human presence without depicting the figures themselves. The two appear as reliefs, only barely distinguishable from the architecture that constrains them. The female figure is placed in the dark shadow of the bay window, her crossed arms underscoring her connection to the house, and the small roof over the door binds the male figure. Both are characterized by a lack of individuality and by the introversion found in other Hopper paintings. They are not aware of the movement in the world around them. This blindness is accentuated by the depiction of the animal, which forms a triangle with the human figures. The dog is placed in the center of the picture, in the midst of the expanse of grass, where the movement is most noticeable. While the couple is untouched by this movement, the dog has focused its attention on it entirely.

For the growing number of his admirers in Europe, *Nighthawks* (Plate

25) is the epitome of Hopper's art, this painting in particular reflecting their idea of the American way of life and Hopper's style. In *Nighthawks* we immediately see that Hopper's understanding of modern man has achieved its definitive expression. This picture speaks directly to the observer, focusing our attention on the people portrayed and their relationship to each other. In the wedge-shaped, protruding building that occupies the greater part of the picture, a panoramic window allows us to look in on the brightly illuminated scene and the arrangement of the figures. There is no interaction between them; only their formal juxtaposition is depicted. The silent, introverted figures are surrounded by objects and are not aware that they too have become objects, reduced to mere functions. As in *Gas,* the parallels between the human figures and the objects are evident. The configuration of the couple is picked up again in the two coffee machines as well as in the salt and pepper shakers. The regular placement of the stools indicates that the people have pre-assigned places. A qualitative difference between the human sphere and that of the objects is not evident; the objects are by no means enhanced by the human presence. Here we have a convincing visual expression of what Marx meant by the process of reification: that the relations between people take the form of objective relations between things.

In *Nighthawks* the only traces of movement are outside the brightly illuminated and clearly structured interior. On the sidewalk and in the window of the house across the street a fine, fleeting movement of light enfolds. This stands in contrast to the rigid order centered around the people. In the play of light we again see traces of that "other" reality dealt with again and again in Hopper's paintings.

6

A consideration of Hopper's work would be incomplete without looking at some of his later pictures, in which his ways of seeing and painting achieved full fruition. In connection with *Roofs of Washington Square* (Figure 1) we postulated an observer whose "absolute" way of perceiving does not categorize objects according to their usefulness nor seek to possess them. This way of perceiving the world, however, was not achieved by any of the human figures depicted in Hopper's paintings. Not until his later works did a changed view of man appear. In *Morning Sun* (Plate 35), for example, painted in 1952, a person is portrayed for the first time as a fully perceiving being; the picture successfully depicts the mediation between inner reality and the outside world.

To grasp what is being visualized in this apparently barren scene, one must look for a new understanding of reality gained by man's turning to face the outer world. This opening-up is achieved not through action, as is often the case, but rather through an unreserved acceptance of what is empirically given. What is visible is modified by neither activity nor subjective interpretation. The woman's posture reveals her concentration, directed completely toward the light streaming into the room. This distinguishes her from his other rigid and blindly introverted figures.

Although we are unable to see what she sees, the entire picture reflects the quality of her vision. The play of light and its shadows underscores her concentration and serenity and at the same time provides the objects with the space necessary to create their own aura. The objects refuse to offer any information about their origin, their history; they have become objects of

pure perception. The building visible outside the room is merely token architecture, lacking the physical presence that would lend it credibility as a place of social interaction. Thus, the building also loses the threatening element found in the urban architecture of Hopper's other pictures.

In these later paintings Hopper sought to express the experience of seeing and perceiving the world by treating light in such a way that it almost becomes a material object. His emphasis on light, the dissolution of material objects, and his ability to visualize an internal reality received its ultimate expression in *Sun in an Empty Room* (Plate 40), one of his last pictures.

Hopper had the rare gift of being able to perceive reality as a whole in the forms of the outside world, of actually *seeing* the truth. In his intuitive perception the objects of the world confronted him with a vitality of their own. Thus, it was not only justifiable but also necessary for Hopper to hold to the empirical forms of the world. They were his starting point, his goal, as well as the means of his art, the unique qualities of which will continue to question any form of abstractionism.

Notes

1. For contemporary American painters' reception of Hopper, see Carl Baldwin, "Realism: the American Mainstream," *Réalités*, April 1973, p. 117.
2. James R. Mellow, "Painter of the City," *Dialogue*, 4 (1971).
3. Brian O'Doherty, "Portrait: Edward Hopper," *Art in America*, 52 (December 1964), p. 73.
4. Hopper frequently uses what appears to be an arbitrary perspective, with the picture frame cutting off the figures and objects—a stylistic method developed by the Impressionists and inspired by early photography. Hopper's individual use of this technique is evident in *Night Windows* (Plate 10), *Room in New York* (Plate 19), and *Office at Night* (Plate 24). The observers perspective appears to be both very high and movable, looking from the outside into the interior of his rooms. This perspective reflects the development from photography to film. Hopper himself said that he was inspired by traveling on the New York elevated railway. (see Gail Levin, "Edward Hopper's *Office at Night*," *Arts Magazine*, 52 (January 1978), pp. 134–137).
5. Gail Levin, *Edward Hopper: The Art and the Artist* (New York, 1980), p. 27.
6. O'Doherty, p. 73.
7. For Watteau's influence on the picture, see Levin, pp. 30–32.
8. Ibid., p. 8.
9. Lloyd Goodrich, *Edward Hopper*, rev. ed. (New York, 1983) pp. 150–151.
10. Levin, p. 51.
11. *Art Journal*, 41 (Summer 1981), p. 150.
12. A similarly clear presentation of the conflict between the human and natural spheres can be found in Dauphinée House, Ryder's House, and *Rooms by the Sea* (Plate 34).

Plates

All paintings reproduced in this volume are oil on canvas.

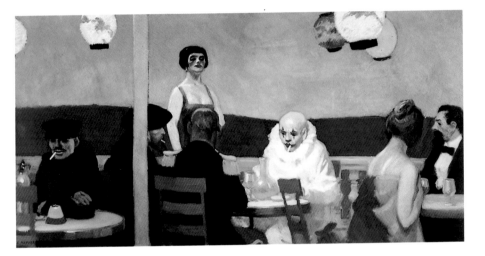

1 *Soir Bleu* 1914

91.4 × 182.9 cm

Whitney Museum of American Art, New York

Bequest of Josephine N. Hopper 70.1208

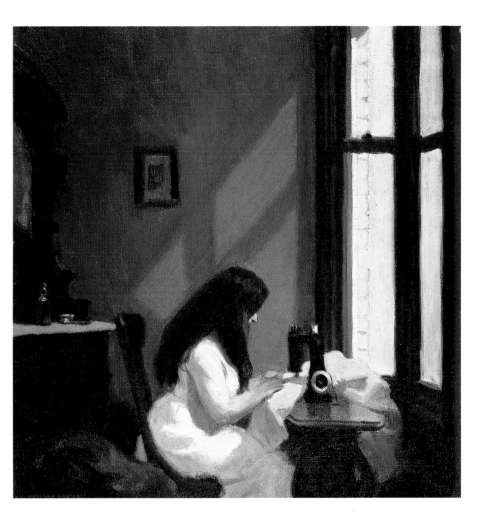

2　*Girl at Sewing Machine*　ca. 1921

48.3 × 45.7 cm

Thyssen-Bornemisza Foundation, Lugano, Switzerland

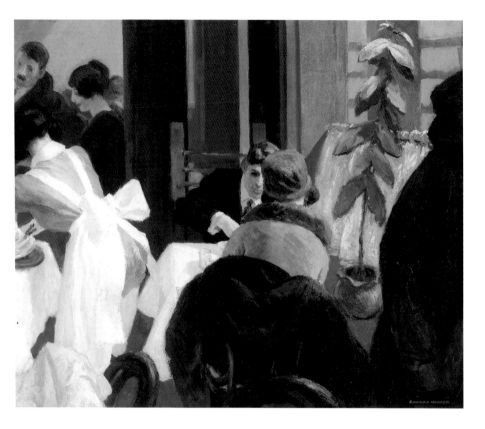

3 *New York Restaurant* ca. 1922

61 × 76.2 cm

Hackley Art Museum, Muskegon, Michigan

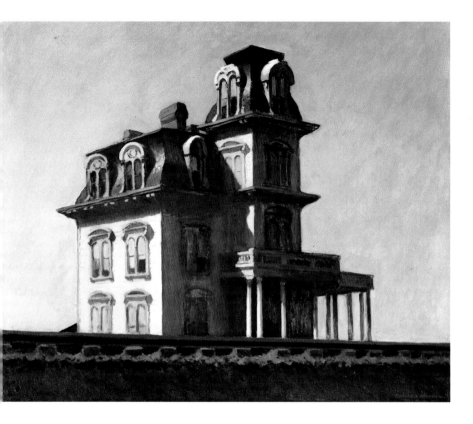

4 *House by the Railroad* 1925
61 × 73.7 cm
The Museum of Modern Art, New York
Anonymous donor

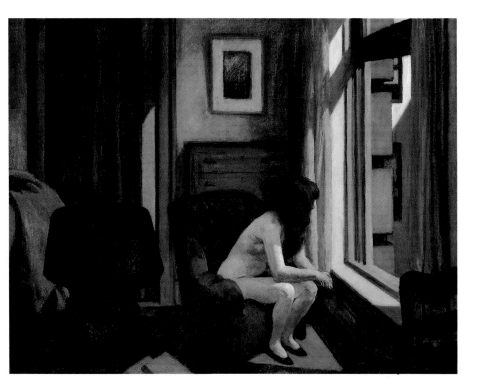

5 *Eleven A.M.* 1926

71.1 × 91.4 cm

Hirshhorn Museum and Sculpture Garden, Smithsonian Institution, Washington, D.C.

Gift of the Joseph H. Hirshhorn Foundation, 1966

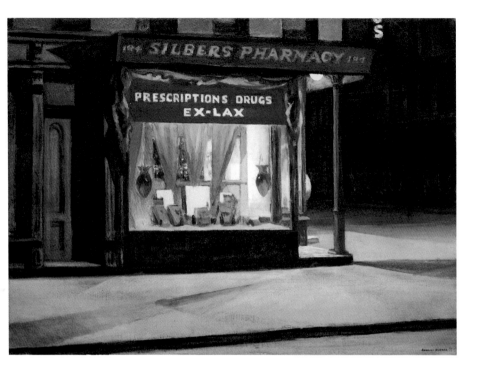

6 *Drug Store* 1927
73.6 × 101.6 cm
Museum of Fine Arts, Boston
Bequest of John T. Spaulding

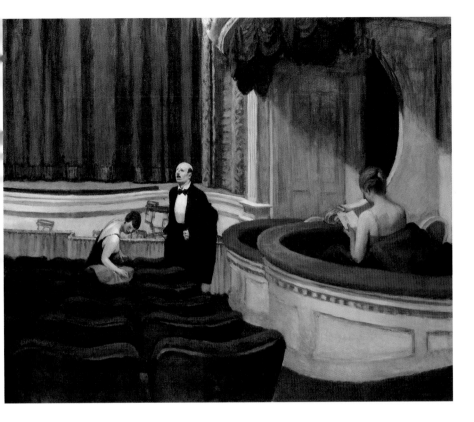

7 *Two on The Aisle* 1927
102 × 122.5 cm
The Toledo Museum of Art, Toledo, Ohio
Gift of Edward Drummond Libbey

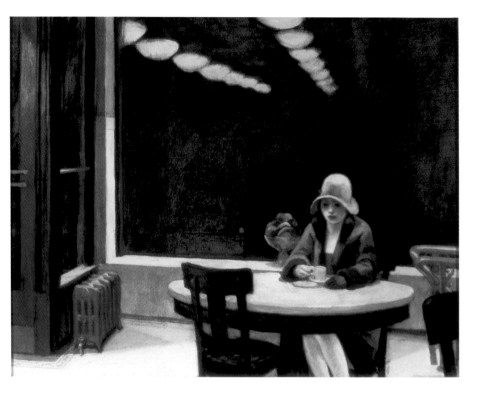

8 *Automat* 1927

71.4 × 91.4 cm

Des Moines Art Center, Des Moines, Iowa

James D. Edmundson Fund

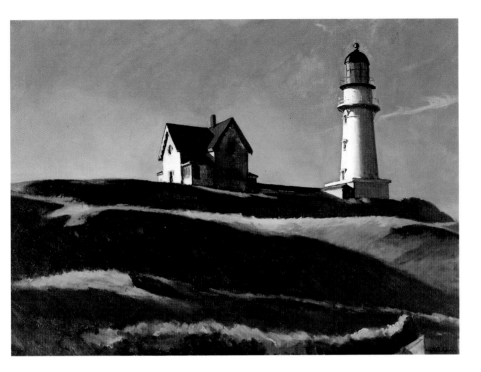

9 *Lighthouse Hill* 1927
71.7 × 100.3 cm
Dallas Museum of Fine Arts, Dallas, Texas
Gift of Mr. and Mrs. Maurice Purnell

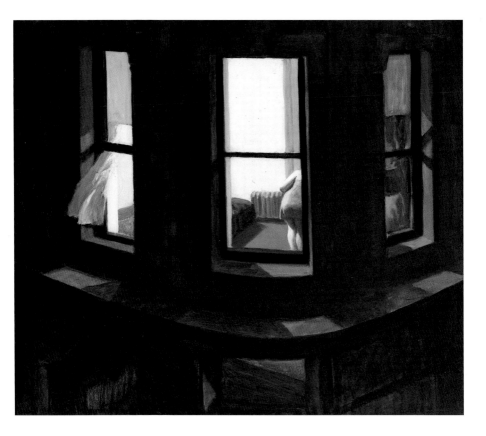

10 *Night Windows* 1928
73.7 × 86.4 cm
The Museum of Modern Art, New York
Gift of John Hay Whitney

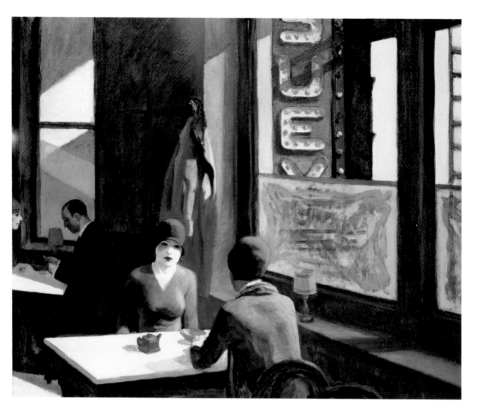

11 *Chop Suey* 1929
81.6×96.8 cm
Collection Mr. and Mrs. Barney A. Ebsworth

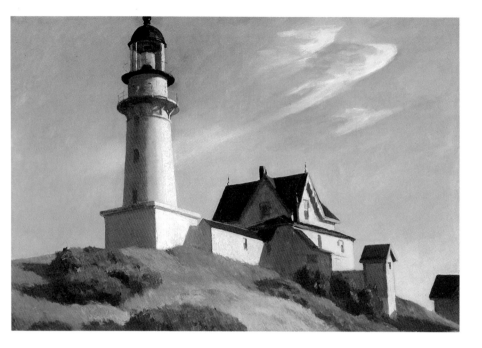

12 *The Lighthouse at Two Lights* 1929

74.9 × 109.8 cm

The Metropolitan Museum of Art, New York

Hugo Kastor Fund, 1962

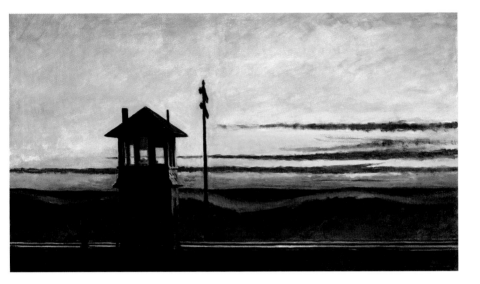

13 *Railroad Sunset* 1929

72.4 × 121.3 cm

Whitney Museum of American Art, New York

Bequest of Josephine N. Hopper, 70.1170

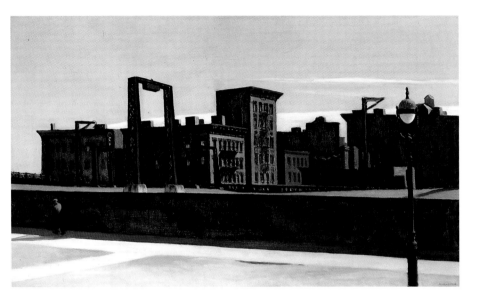

14 *Manhattan Bridge Loop* 1928

88.9 × 152.4 cm

Addison Gallery of American Art, Phillips Academy, Andover, Massachusetts

Gift of Mr. Stephen C. Clark

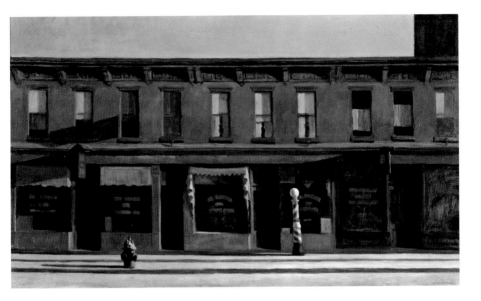

15 *Early Sunday Morning* 1930
88.9 × 152.4 cm
Whitney Museum of American Art, New York
Purchased through the Gertrude Vanderbilt Whitney Foundation, 31.426

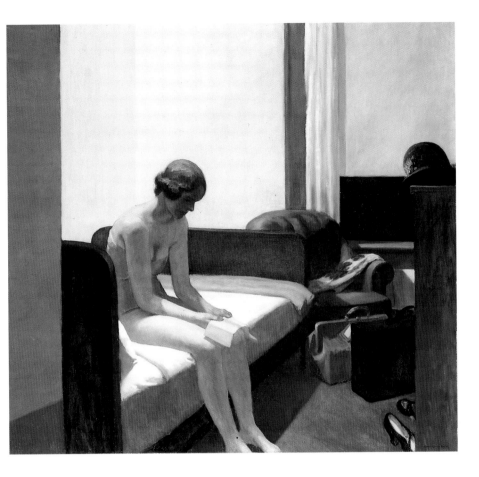

16 *Hotel Room* 1931

152.4 × 165.1 cm

Thyssen-Bornemisza Foundation, Lugano, Switzerland

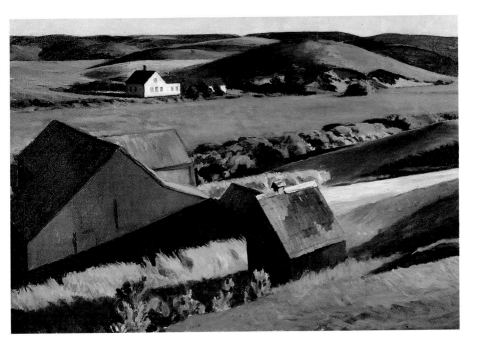

17 *Cobb's Barns and Distant Houses* ca. 1931

72.4 × 106.7 cm

Whitney Museum of American Art, New York

Bequest of Josephine N. Hopper, 70.1206

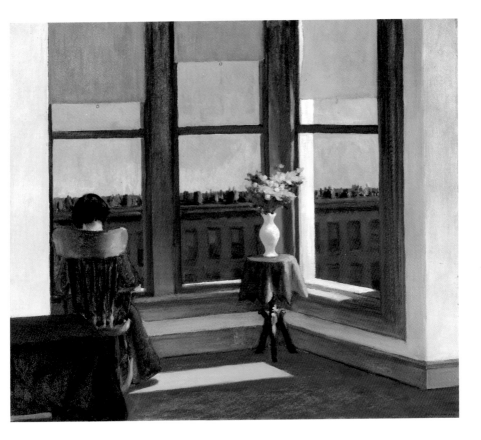

18 *Room in Brooklyn* 1932

73.7 × 86.4 cm

Museum of Fine Arts, Boston

Charles Henry Hayden Fund

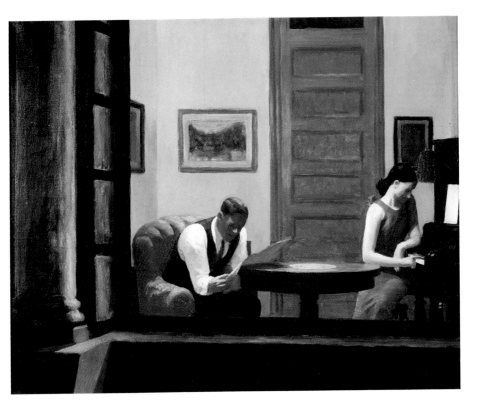

19 *Room in New York* 1932
73.7 × 91.4 cm
Sheldon Memorial Art Gallery, University of Nebraska-Lincoln
F. M. Hall Collection

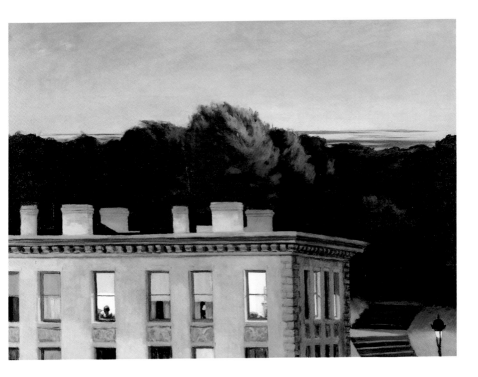

20 *House at Dusk* 1935

91.4 × 127 cm

Virginia Museum of Fine Arts, Richmond

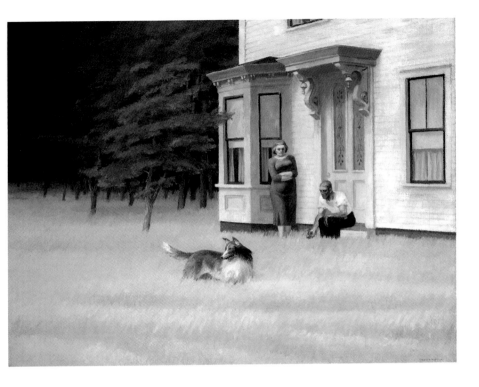

21 *Cape Cod Evening* 1939

76.8 × 102.2 cm

National Gallery of Art, Washington, D.C.

John Hay Whitney Collection

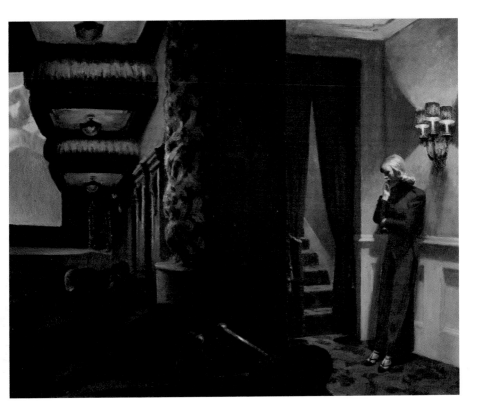

22 *New York Movie* 1939
81.9 × 101.9 cm
The Museum of Modern Art, New York
Anonymous donor

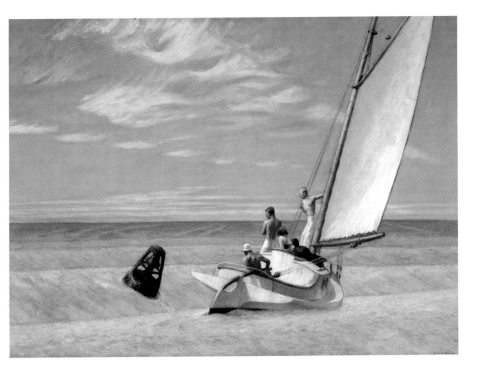

23 *Ground Swell* 1939
91.4 × 127 cm
The Corcoran Gallery of Art, Washington, D.C.
Museum purchase, William A. Clark Fund, 1943

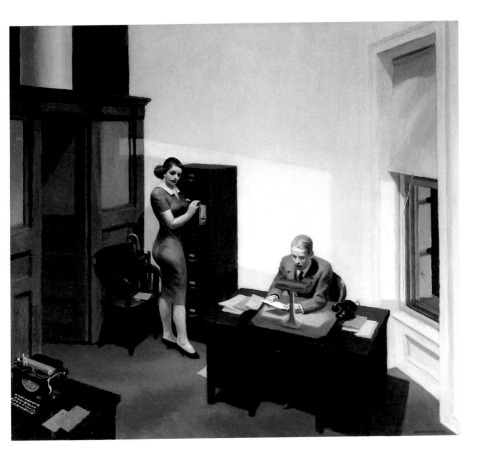

24 *Office at Night* 1940
56.2 × 63.5 cm
Walker Art Center, Minneapolis
Gift of the T. B. Walker Fund, Gilbert M. Walker Foundation, 1948

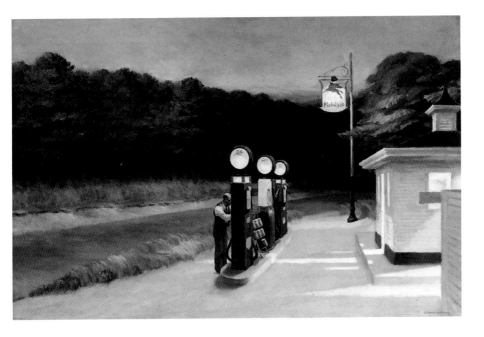

25 *Gas* 1940
66.7 × 102.2 cm
The Museum of Modern Art, New York
Mrs. Simon Guggenheim Fund

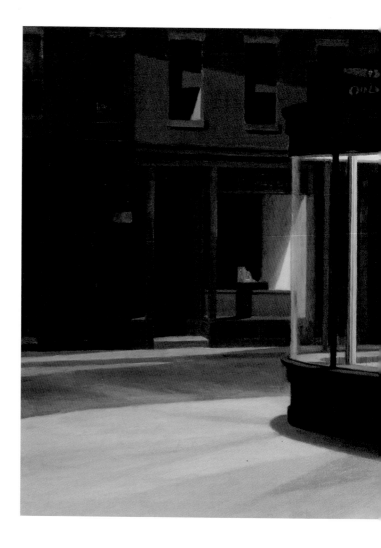

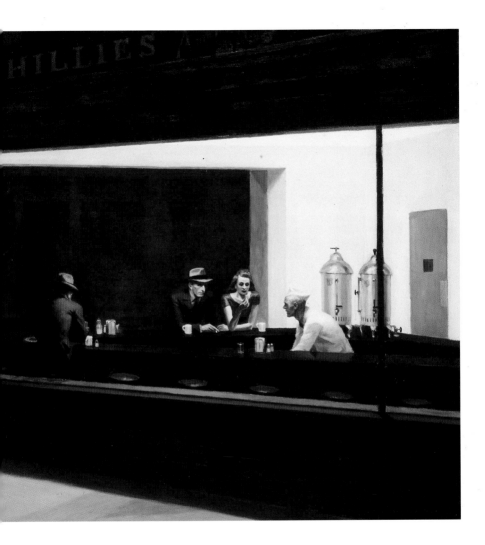

26 *Nighthawks* 1942

76.2 × 152.4 cm

The Art Institute of Chicago

Friends of American Art, 1942.51

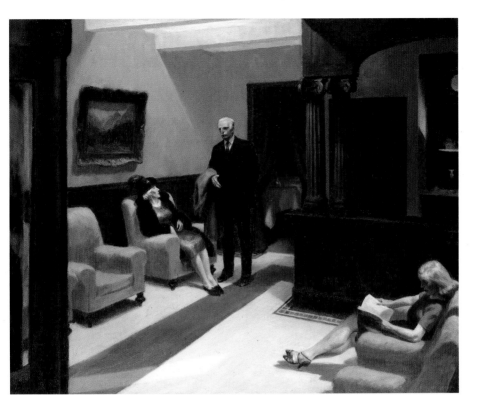

27 *Hotel Lobby* 1943

82.5 × 103.5 cm

William Ray Adams Memorial Collection

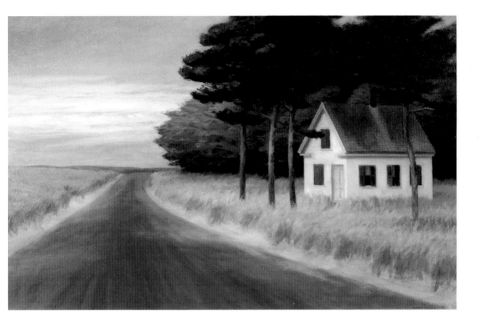

28 *Solitude* 1944

81.3 × 127 cm

Private collection, USA

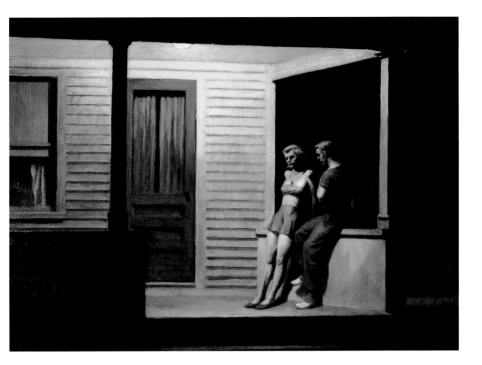

29 *Summer Evening* 1947
76.2 × 106.7 cm
Mr. and Mrs. Gilbert H. Kinney Collection

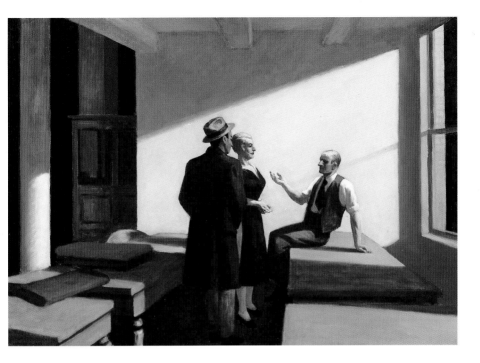

30 *Conference at Night* 1949

70.5 × 101.6 cm

Wichita Art Museum, Wichita, Kansas

Roland P. Murdock Collection

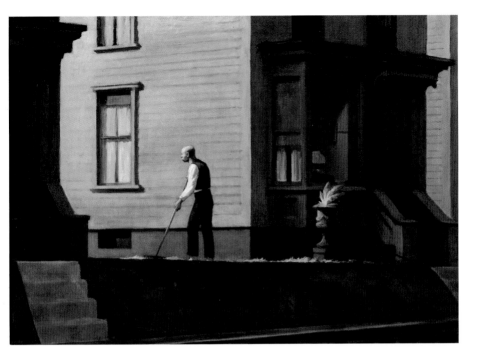

31 *Pennsylvania Coal Town* 1947
71.1 × 101.6 cm
The Butler Institute of American Art, Youngstown, Ohio

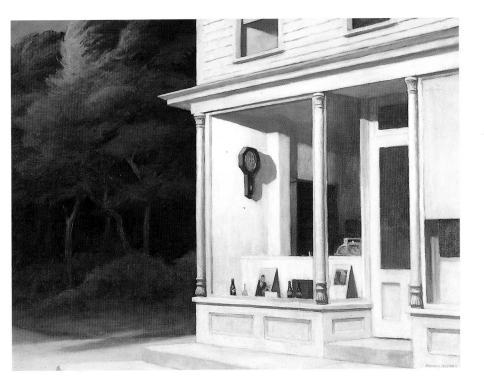

32 *Seven A. M.* 1948

76.2 × 101.6 cm

Whitney Museum of American Art

Purchase 50.8

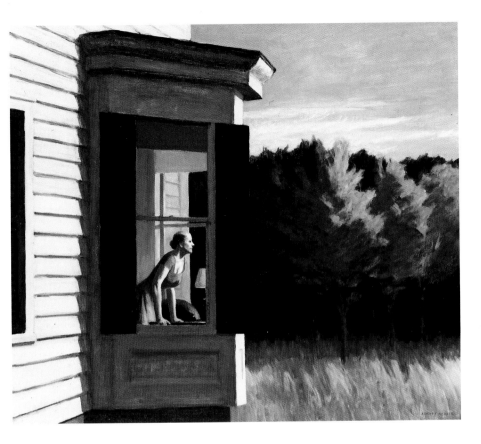

33 *Cape Cod Morning* 1950

86.4 × 101.6 cm

National Museum of American Art, Smithsonian Institution, Washington, D.C.

Gift of the Sara Roby Foundation

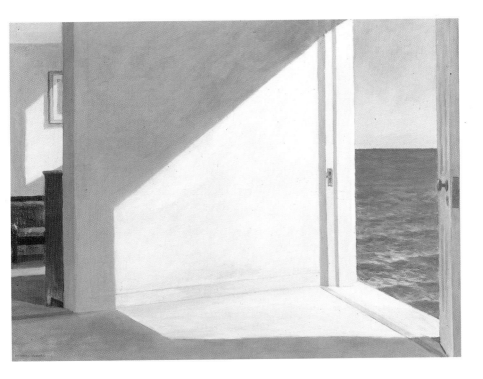

34 *Rooms by the Sea* 1951

73.7 × 101.6 cm

Yale University Art Gallery, New Haven, Connecticut

Gift of Stephen Carlton Clark, B.A., 1903

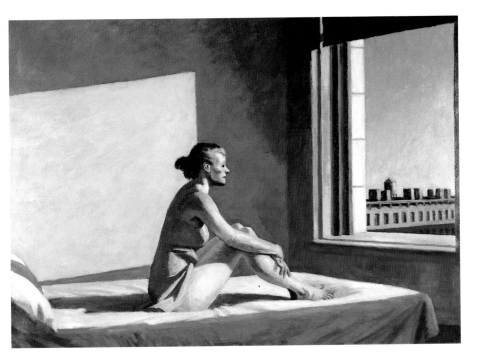

35 *Morning Sun* 1952
71.4 × 101.9 cm
Columbus Museum of Art, Columbus, Ohio
Howald Fund Purchase

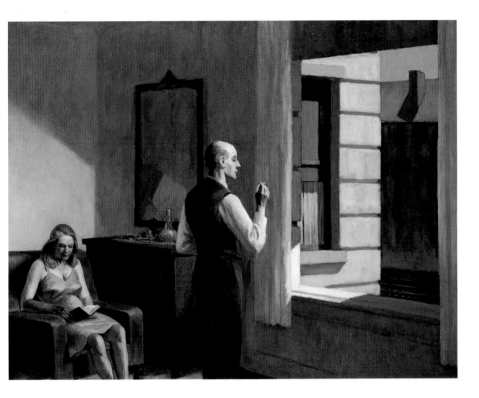

36　*Hotel by the Railroad*　1952

78.7 × 101.6 cm

Hirshhorn Museum and Sculpture Garden, Smithsonian Institution, Washington, D.C.

Gift of the Joseph H. Hirshhorn Foundation, 1966

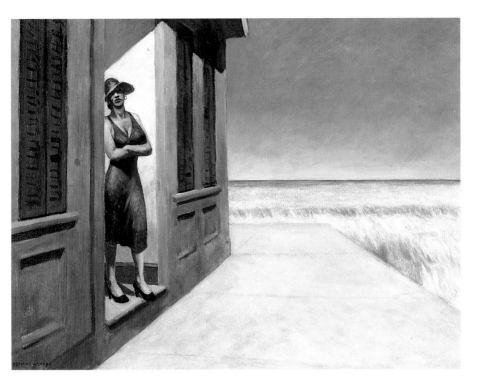

37 *Carolina Morning* 1955

76.2 × 101.6 cm

Whitney Museum of American Art, New York

Donated by his family, in memory of Otto L. Spaeth, 67.13

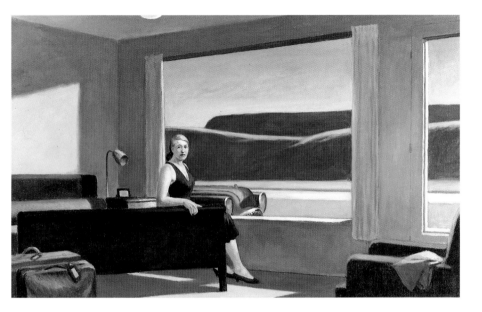

38 *Western Motel* 1957

76.8 × 127.3 cm

Yale University Art Gallery, New Haven, Connecticut

Gift of Stephen Carlton Clark, B.A., 1903

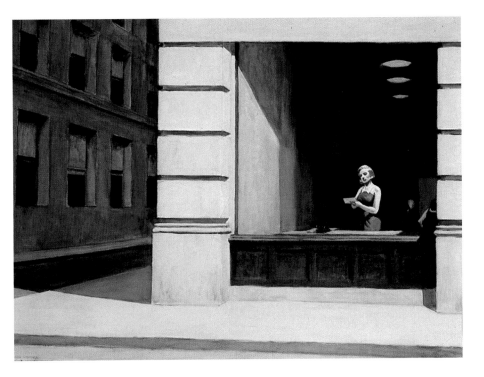

39 *New York Office* 1962
101.6 × 139.7 cm
Blount Collection, Montgomery, Alabama

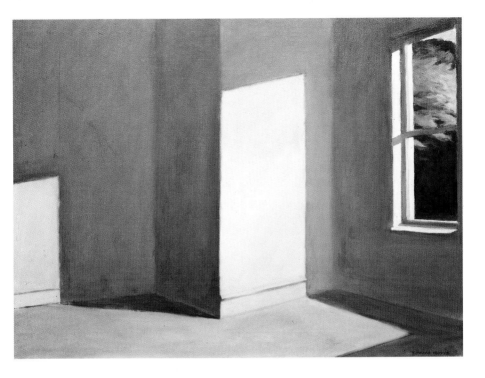

40 *Sun in an Empty Room* 1963

73 × 100 cm

Private collection, Washington, D.C.

Selected Bibliography

Goodrich, Lloyd: *Edward Hooper*. New York: Abrams, 1985.
Levin, Gail: *Edward Hopper as Illustrator*. New York: Norton, 1979.
————*Edward Hopper: The Complete Prints*. New York: Norton, 1979.
————*Edward Hopper: The Art and the Artist*. New York: Norton, 1981. (Includes additional bibliographical listings.)
————*Hopper's Places*. New York: Knopf, 1985.
Liesbrock, Heinz: *Edward Hopper: Die Wahrheit des Lichts*. Duisburg: Trikont, 1985.

Chronology

1882 Born on July 22 in Nyack, New York.

1888–99 Private school in Nyack and Nyack High School.

1900–1906 At the New York School of Art, studies illustration with Arthur Keller and Frank Vincent DuMond, then art with Robert Henri, William Merrit Chase, and Kenneth Hayes Miller.

1906 Employed as an illustrater by C. C. Phillips & Co., New York. In October leaves for Paris.

1907 Stays in Paris until August, then travels to London, Amsterdam, Haarlem and Berlin.

1908 Participates with other Henri students in the Exhibition of Paintings and Drawings by Contemporary American Artists, New York.

1909 Second trip to Paris.

1910 Exhibition of Independent Artists, New York. May–July: Paris and Madrid. Returns to New York and supports himself with illustrations and commercial art.

1912 Group exhibition at the MacDowell Club, New York. Regular contributions in oil, watercoloring, graphics and sculpture to the biannual exhibitions of the MacDowell Club.

1913 Summer spent in Gloucester, Massachusetts, painting; sells one oil painting. Moves to studio on Washington Square, New York, where he resides until his death.

1914 Exhibits with other artists at the Montross Gallery, New York; summer in Ogunquit, Maine.

1915 Hopper finishes his first etchings. He spends the summer again in Ogunquit, Maine.

1916 Summer on Monhegan Island, Maine, where he spends his holidays in the years following.

1918 Hopper's poster design *Smash the Hun* receives first prize in a national contest for war posters.

1920 First one-person show (sixteen oil paintings) at the Whitney Studio Club, New York. As a member of the Whitney Studio Club, takes part in the members' exhibitions, held several times a year.

1923 Attends evening courses at the Whitney Studio Club, drawing many models. Participates in a group exhibition of etchings at the Art Institute and in a group exhibition at the Academy of Fine Arts in Philadelphia. Finishes his last etchings. Spends the summer in Maine and begins to paint watercolors. Enters six watercolors in a group exhibition at the Brooklyn Museum, of which one is bought.

1924 Participates in a group exhibition at the Academy of Fine Arts in philadelphia, at the Art Institute of Chicago, and at the Whitney Studio Club. Marries Josephine Verstille Nivison. They spend the summer in Gloucester, Massachusetts. The Frank K. M. Rehn Gallery, New York, exhibits eleven of his recent watercolors in late autumn; all are sold. The success enables Hopper to abandon his commercial art.

1925 Travels to Colorado and New Mexico.

1926 Participates in a group exhibition at the Boston Art Club. Extended stay in Maine and Massachusetts.

1929 Second one-person exhibition at the Frank K. M. Rehn Gallery, New York, with twelve oil paintings, ten wtercolors, and a series of drawings.

1930 Founding and opening of the Whitney Museum of American Art, New York, by Gertrude Vanderbilt Whitney.

1932 Elected to the National Academy of Design; he declines the nomination, since his paintings were not accepted in earlier years. Rents additional studio space on Washington Square. Represented in the first biennial of American art at the Whitney Museum (and in almost all those following).

1933 The Hoppers buy land in South Truro, Massachusetts, on Cape Cod. First retrospective at the Museum of Modern Art, New York, with twenty-five oil paintings, thirty-seven watercolors, and eleven prints.

1934 Retrospective at the Arts Club of Chigaco. A studio-house is built on the property in South Truro; here the Hoppers spend their future summers.

1935 Awarded a gold medal by the Academy of Fine Arts in Philadelphia. The Worcester Art Museum awards him the first prize for watercolors.

1937 Awarded the Gold Medal and the first W. A. Clark Prize of the Corcoran Gallery of Art, Washington, D.C.

1941 Two-month journey on the West Coast by car.

1945 Named an honorary member of the Art Institute of Chicago; later elected to the National Institute of Arts and Letters.

1950 Retrospective at the Whitney Museum of American Art; also shown at the Museum of Fine Arts, Boston, and at the Detroit Institute of Arts. Honorary doctorate from the Art Institute of Chicago.

1952 Selected by the American Federation of Arts as one of four American artists to represent the U.S. at the Biennale in Venice.

1953 With a group of other realist artists, founds the journal *Reality*.

1955 Recieves the Gold Medal for Painting of the American Academy of Arts and Letters.

1960 Recieves the Art in America Award.

1962 Exhibition of his complete graphic works at the Philadelphia Museum of Art and then at the Worcester Art Museum.

1963 Retrospective at the Arizona Art Gallery, South Truro, Massachusetts.

1964 Illness prevents Hopper from painting. Major retrospective at the Whitney Museum of American Art, New York, which afterwards is shown at the Art Institute of Chicago, the Detroit Institute of Arts, and the St. Louis Art Museum.

1965 Honorary doctorate from the Philadelphia College of Art.

1967 Dies on May 14 in his studio on Washington Square. Hopper's works are displayed in the U.S. pavilion at the Ninth Biennale in São Paulo.

1968 His remaining works are bequeathed to the Whitney Museum of American Art.

1980 Major retrospective of Hopper's complete works at the Whitney Museum of American Art; shown in Europe the following year.

Photo credits